Art Center College of Design
Library
1700 Lida Street
Pasadena, Calif. 91103

D1179946

3 3220 00256 5872

ART CENTER COLLEGE OF DESIGN LIBRARY

Schirmer's Visual Library

Man Ray—Photographs, Paintings, Objects

André Breton described him as an "unpredictable gambler, the pioneer of things as yet unseen, the shipwreck of all that is predictable." During the first half of this century, Man Ray (1890-1976), an American who was Modernism's "uomo universale" in the true sense of the words, again and again set the international Dada and Surrealist movements into transports of enthusiasm with his photographs, paintings, and objects—although the movement itself was not exactly short of astounding artistic innovativeness. A friend of Marcel Duchamp an many other artists, Man Ray portrayed the creative élite of his time—Salvador Dalí, Picasso, Luis Buñuel, James Joyce, and many others. He founded modern object art, and raised photography once and for all to the level at which it was recongnized as being an artistic genre in its own right. In addition—as his autobiography, *Self Portrait,* shows in a rich variety of ways—he was an acute observer of his times, probably the most creative and imaginative source of inspiration, and a pioneer for all the essential avant-garde movements of the 1920s and 1930s. Many of his works, the most significant of which are presented in this book in each of the genres Man Ray used and supremely mastered, became artistic milestones of an entire epoch. The introductory essay is by the Italian art scholar and critic, Janus.

120 pages, 47 duotone and colour plates

MAN RAY

709.73
M266
A36
1997

Photographs, Paintings, Objects

With an essay by
Janus

W. W. Norton & Company
New York · London

In memory of Jerome Gold

Cover illustration:
Imaginary Portrait of D.A.F. de Sade, 1938
Oil of canvas and wood, 54.9 x 45.1 cm
The Menil Collection, Houston

The essay by Janus was translated from French by Jamie Wiens
Translation from German by Michael Robertson

© 1997 by Schirmer/Mosel GmbH, Munich
All rights reserved. No part of this publication may be reproduced,
stored in a retrieval system, or transmitted, in any form or by any means,
electronic, mechanical, photocopying, recording, or otherwise,
without the prior permission of the publishers.

Lithos: O.R.T. Kirchner & Graser GmbH, Berlin
Typesetting: Typ-O-Graph, Munich
Printing and binding: EBS, Verona

ISBN 0-393-31624-6

A Schirmer/Mosel production
Published by W. W. Norton & Company
New York · London

CONTENTS

Janus

IN MAN RAY'S CENTURY

Who was Man Ray really? A painter? A photographer? A graphic artist? A draughtsman? A film maker? A sculptor? An inventor of objects? Or an author who wrote hundreds of pages of thoughts, stories, critical essays or perhaps even a novel...? The various aspects of the body of his works are indissociable from one another: to isolate them would be to risk making gross erros of interpretation. Just as one begins to take an interest in the aspect of photography, it tends toward painting; and those convinced they are face-to-face with painting discover that it disappears into photography. Drawings become sculptures (*Les mains libres,* for example), paintings become objects, and objects are transformed into paintings. In acutal fact there is a continuous coming and going between the genres, a displacement of shapes and materials which finally converge towards the same goal: making art the science that it truly and rightfully is.

A long way from Duchamp's esotericism and Picabia's improvisations, Man Ray is pure rationality. He is a cerebral artist who builds one of the many worlds it is possible for the mind to live in. His works, whatever technique they assume, strive towards this goal: they occupy the squares on a gigantic chess board. Without the least aesthetic or spiritual concession, Man Ray's art always has a very specific aim: that of the meticulous transposition of his dreams and thought processes within a mechanical field. That was always the starting point for each of his creations. It was never pure inspiration, nor an attraction to either fantasy or illusory esoterical myths, but rather the idea of a universe made up of atoms an machines. Not that mystery did not hold an attraction for him—quite the opposite—yet, when his analysises were completed, everything mysterious and unknown had to assume an extremely concrete, well-defined character. Here we already get a glimpse of his philosophic attitude to the elusive world whose original appearance, or at least one of many possible original appearances, the artist strives to capture. We have often emphasised the significant encounter which brought together the young Man Ray and Stieglitz, and the latter's very sophisticated cultural circle. And, of course, there was his encounter with Duchamp in 1915, a relationship that was not at all one-

sided, but truly reciprocal. Man Ray did not need much stimulus to develop his personality or to orientate his research towards the Dadaist movement. A third encounter that was perhaps even more crucial was his association with Francisco Ferrer's anarchist circle in New York where, upon studying nudes, he attained his most original social conceptions. He immediately found a world there which corresponded to his way of thinking. There were professors and students who were actually able to put their ideas into practice by founding the anarchist colony of Ridgefield, a small and, at that time, almost uninhabited, rural community in New Jersey near New York. Ridgefield was where Man Ray founded and put together his first anarcho-artistic review called *The Ridgefield Gazook* (March 31, 1915). Its agenda was very satirical—not just satirical but as bombs ready to go off against society. In the following years Man Ray remained true to this very enterprising manner of attacking society, whether it was with an iron covered with spikes, more threatening than a weapon, or with the idea he expressed in his later years that, had he not been so lazy, he would rather have been a gangster than an artist.

A review entitled TNT (the symbol for toluene) appeared in March 1919, designed by Man Ray himself, and Adolf Wolff, an anarchist sculptor who had been imprisoned several times. Was Man Ray potentially explosive? That was precisely his intention, even though he had always been a harmless terrorist—a terrorist in the field of art, a spiritual revolutionary. However we must try to see a social élan underlying the creative apparatus of his work, which was never openly stated out of a sense of decency, but whose seeds were sown in Francisco Ferrer's circle (a Spanish revolutionary who ended up in front of a firing squad). Even at the beginning of his career, neither academics nor tradition sufficed for Man Ray. Only what rebelled, even in a confused manner, against traditional bourgeois society satisfied him. The significance of Man Ray's and Ferrer's collaboration is also emphasised by the fact that the first exhibition of Man Ray's works took place in 1912 at the Ferrer Center. With Marcel Duchamp and Katherine Dreier, he founded *Société Anonyme,* the first American museum of modern art, which had no fixed address and moved its exhibitions around the world. The name, for aesthetic reasons, was taken directly from the worlds of industry and commerce rather than the art world. Upon closer examination of the different facets of Man Ray's intellectual behavior and work, it is more and more obvious that his artistic problem was, right from the start, a scientific problem: art is a device which has to be constantly wound up then wound down. It is a complex system in which the technique and the materials used play a prominent

role and the mind is forced to retreat like an absurd relic of the past. Before we can perceive Man Ray as an artist, we see him as a scientist who analyzes the contradictions of culture. His work seems to suggest that man must first explore science before he becomes an artist.

The object

Man Ray's work, in its different orientations, focuses directly on the core of the problem: transformation from within the image—not the aesthetic image but rather the scientific image, the image of the technique, that of society—in other words, the image of knowledge. He erects a city where the mannequins, the real shadows and the artificial shadows, the subjects, dictate their own laws. If we scan the world of his "objets d'affection" (familiar objects), we are plunged into a universe we never tire of exploring; the limits of which are constantly being pushed back according to the whim of the builder and also according to the particular angle of those contemplating it; an angle which gradually lures and captures the beholder. It is a world of infinite dimensions where no object is ever in its right place. the object is always sliding out of its contours, in an attempt to completely transform its appearance. Even the titles Man Ray gave these works contribute to their movement in space: he wrenched them out of their bourgeois origins and inserted them into a world of a different mental equilibrium, the purpose being to provoke as well as to stimulate. Whatever do these objects want—objects that do not even weigh as much as a feather or which enclose steel balls in a jar of olives or which achieve an endless number of deviant combinations with scraps of wood, metal or cloth? They surely want to revive a sense of wonder and possibly, while shocking those who have never accepted any manipulation of traditional images. Yet they also have a more ambitious goal: they wish to substitute the image the bourgeoisie itself—usually so placid, so sensible, and so virtuous—has of the image, with one that is removed from this same bourgeoisie. Man Ray does not like this type of virtue. Who could possibly deny that middle class virtue is itself loaded with horror? The "objets d'affection" are a form of punishment that Man Ray sadistically inflicts upon the middle class. He is punishing it for always having been so blind, for never having suspected that other mirrors and other visions do exist. His art is a series of floggings, much the same as the flagellation in which Sade's characters so often lustily indulge. This

philosophic interpretation leads us into the labyrinth of objects where we can observe them at last in their naked reality, like sharp instuments ready to wrest presupposed realities, and codified by moral laws or intellectual laziness from their foundations. Through these works, which accompanied Man Ray throughout his entire life, he demonstrates just the opposite: the middle class is neither good nor virtuous. It is not the sole agent of truth, even when confronted with an accurate representation of the image.

The objects are tangible proof of a kind of coherence in the midst of the most paradoxical and the most disconcerting propositions. They are not toys—at least not only toys—but rather caustic, dangerous weapons in the hands of a man with a very powerful mind, using them to stir things up among his enemies as well as to assert his truth and the right to have an unorthodox vision of life. These objects reveal a capacity to express firmness, perseverance, and earnestness in the midst of an apparent deconsecration of forms and established customs. In their own way, they suggest their own syntax of life and their own proletarian ethic which is simpler, more immediate and, moreover, truly essential. They can only be conceived by a society that is poor, humble, and oppressed. When that society begins to acquire wealth and power, the myths of a world which demands complete obedience from the men and the objects they manipulate are no longer appropriate. The wealthy classes need perfectly recognizable objects which can be used safely, never outside their natural surroundings. Man Ray's "objets d'affection"—we prefer to call them "non-natural objects"—are the antithesis of all this: they are not recognizable, they serve no purpose whatsoever, and may even prove dangerous—at least for our minds. They do not, however, represent radical negation like Duchamp's which constantly graze the void. Man Ray must make a statement and even give meaning to his forms whereas Duchamp, in each of his *ready-mades* goes as far as to exclude even thought. Man Ray is neither a painter, nor a film maker, nor a photographer. Instead he could be defined as a "master painter" or as an "intellectual painter." It is impossible to say which of his objects is most evocative because that is not their purpose. They are aspiring to simplicity of expression rather than to the status of masterpieces. It seems their didactic and scientific aim prevails over all other considerations because they belong to a sort of semantic chain, whose precise purpose is utility and, subseqently, a contribution to the definition of the man of the future.

Irons covered with spikes, of which there are several versions (because in art, too, *repetita juvant*), metronomes with or without hypnotic eyes, bars made of bronze

or painted blue, plaster pipes crowned with a glass bulb, musical instruments with no strings, mannequins always ready to be used in a sexual education course (again, the ironic educational goal reappears here), lampshades and coathangers which are neither lampshades nor coathangers, and numerous other disrespectful conversions of matter (that is to say, ethics) make up the outline of a long story which is a kind of cross between a "philosophical novel" and *Commedia del Arte.*

Finally, they are transparent objects which allow us to go beyond the object and the surface of things, to arrive at more complex reasoning about the ambiguousness of the senses. They are like the jar of jam Alice catches in mid-air in the White Rabbit's hole, or like the food and drink that makes her shrink or grow at will. Man Ray's objects (as well as his photographs) constantly emphasize the idea that shapes either stretch physically into space or else disappear.

The object as machine

In the past there were far fewer objects for several reasons. Industry was not yet able to flood the market with series of mass-produced items and man felt less of a need to be surrounded with fetishes and material things—objects in which he could see his own reflection and which he could use. His needs were indubitably more limited: the age of waste had not yet arrived, the era in which we need everything and at the same time consume everything as soon as we get our hands on it. Therefore, art, although divided into major arts and minor arts, did not require a very large number of objects to put in its museum, other than traditional objects handed down through the ages, which included everyday utensils. Nobody could have suspected that one day it would be possible to reproduce objects and with such rapidness.

Art has discovered how to make its way into even what is useless or discarded, and into rubbish and the recycling of what has been cast off or destroyed too hastily. Man Ray's "objects" take their place in this void, in this space that was just waiting to be filled. The objects are never arbitrary or fortuitous, they are constructed for the distinct purpose of intellectual knowledge. They belong to a kind of art factory and therefore are proud to be a part of the civilization of their time, like perfect thinking machines, aware of the indispensable mechanisms of life.

The machine is Man Ray's object, one more instrument at our disposal that interrogates us about the world's destiny, like a key that may fit many locks or perhaps

none at all, starting with the objects of his pre-Dada period to his "objets d'affection" and his "mathematical objects." On the one hand, his "objects" are solitary presences but, on the other hand, they are like the tumult of a crowd. They are completely individualistic if we take into account the tendencies of their inventor, yet they are also endowed with a collective strength considering they can be reproduced and regenerated ad infinitum. This is due to another of Man Ray's tendencies, which was to deem the objects he created unique and unreproducable, especially from the point of view of others. Yet immediately afterwards he wanted them to be widely propagated and duplicated in unlimited quantities, which is the only way an object can hope to survive in a society that destroys everything it uses and everything it looks at. From a philosophical point of view, the object is more important than the painting, the latter remaining unprotected against the ravages of time and the indestructibility of the structure of the object itself. Man Ray went much further in that direction: he believed that the reproduction of a painting in a catalogue, or better yet, a book, was much more significant than the painting itself, which would thereby be completely useless in real life and become a simple product or commodity no longer bearing any relationship to art. Faithful representation of the object is truly the pure, unique work of art we should consider as it is free of any commercial or economic contamination. As Man Ray specifically states in his autobiography on the subject of one of his most famous paintings: *A l'heure de l'observatoire, les amoureux;* "I will not be satisfied until I have seen it reproduced in color on two full pages in a book on surrealism. Only then will I be assured of its permanency. I am much less worried about preserving the originals."

Photography

Thus we can understand how photography became Man Ray's subject par excellence since it fulfills all the requirements of this philosophical concept: the speed of execution and synthesis; the fact that it is impossible to refer back to an illusory original model (there is no illusory original and the negative itself can be reduced); that the image can be reproduced ad infinitum; and, at the same time, that an analogous wealth of variations and transformations can be made from the negative in the processing room. Photography is therefore the intellect's most perfect creation. It is always its own equal regardless of its diversity. The space that separates the internal

and external image is more immediate and much smaller than that between a picture and its reproduction on the page of a book. A picture can easily die and disappear. The instant it is captured by the camera the model, which was the point of departure, no longer exists.

If we are determined to find an original, it exists or existed in the landscape selected by the photographer, in the surroundings of the house photographed, in the person who posed for the camera. In short, the original is the model. Duchamp, Tristan Tzara, Virginia Woolf, or Sinclair Lewis who, like many other protagonists of modernism, were photographed by Man Ray, died or vanished long before their actual demise, at the precise moment that they complied with the photographer's wishes. At that very instant they dissolved in space, became unreal, were transformed into phantoms. What remained of their lives when they resumed them was no longer relevant to the destiny of the photograph: it was already something different which might not even resemble the photographic image. From an absurdist's point of view, we could say that if someone wanted to go into business in photography, rather than selling the photograph he should sell the subject, whether it be a landscape, a still life or a person in the flesh—who is more bones than flesh now. This is why Man Ray often photographed objects he had invented and built expressly to be photographed. And even then no distinction was to be made between the the photograph of an object and that of a real person.

Man Ray, in essence, accomplished the revolutionary act of always photographing the photograph, which is entirely different from photographing objects that are completely outside the photograph. This is a unique attitude, and nothing in traditional or non-traditional practice can be compared to it. Man Ray is photographer and subject. His shadow is always behind the camera, which is always a little beyond the image. The camera itself is constantly reflecting as if there were an infinite distance between the artist using it and the reality depicted, but it is always aware of its ultimate destruction. There is no model in the middle, there is only what Man Ray wants to see and sees, what he wants to imagine and imagines. In reality the imaginary model is hidden and only the ideal model remains: the photograph looking at the photograph, the photograph that reproduces, the photograph that takes the photograph, and the photograph renewed in its destruction and its eternity.

We are in the process of creating a new genealogy of photography which will tell the story of the earth in every detail for a posterity already inclined to be stunned and distressed by it. Man Ray is right in the middle of this revolution, between the object—object which reproduces a world of fantasy, and the object photograph which reproduces the hypotheses of the image. On the one hand we have the intellectual, artificial object, and on the other the proletarian, collective object, which stretches for an infinity before our eyes, portrait without a portrait, landscape without a landscape, compositions which dissolve immediately after being photographed, and the photograph that looks like a mask. At this point the image even escapes the camera—collage, photogram, solarization, etc. where Man Ray's mind developed with equal intellectual vigor—perfectly closing the circle of art, since the camera without a photograph is the artistic paradox par excellence. It is perfection without a need for action, thought without need for thinking, a divine machine which has henceforward created everything, a machine in its own image. The camera no longer needs to take photographs. All it has to do is exist in itself for itself, above man because, in that absolute solitude which has become its own, the Machine is Man.

Thus for Man Ray, the camera has a dual function: it both attracts and repels the image; it penetrates reality or emerges from it; it embraces yet is excluded from the frontiers of the world; it is, at one and the same time, the most necessary thing in the world and the most useless. The camera is already part of a sort of cemetery in which it is an instrument of truth but above all it is an instrument of death. Its job is to kill at the very moment it comes face to face with reality and the image born of it is like a cadaver on an vivisection table. The photographer-artist is the only one who attempts to bring it back to life so that he can pass it on to the future. Man Ray is the exorcist wandering among the sepulchres of the world, evoking what life never ceases losing, ready even to kill the camera (with the photogram) when he realizes that it has become, above all, an obstacle. Thus, creating a photograph without using this obstinate mechanical or electronic presence means constantly turning the facts on their heads, denying the camera part of its power and part of its fiction, resisting its indisputable power and arrogance as well as its implacable inner cruelty.

The photogram, for example, has the extraordinary distinction of belonging to

ART CENTER COLLEGE OF DESIGN LIBRARY

two distinct spheres of knowledge, man's and the machine's, both of which stress the fundamental question of human identity. The photogram has a social aspect which indirectly describes our times better than any illustration or graph. It turns the image inside out to be seen from within and moves it dialectically from an often illusory proximity to an often more objective harmony. In this oscillation between two moments, both of which are very important, resides its great polemic strength. All photographs, from the oldest to the most recent, should be looked at and judged in that light. They all fall within the domain of the photogram even when the technique is different, as if the slightly aberrant, slightly heretical element of the photogram were insinuating itself into the fragments of the images. We are not thinking only of the old glass plates of the American period, nor of the classical, hermetic *Elévage de poussière* which in itself deserves a book, but of the *Voies lactées,* which numbers among his last photographs, taken with a camera in the traditional manner, but which bears no trace of having been created by a camera. Thus the photograph constantly involves the machine and its negation, but the camera is always elsewhere. In fact, it is in the eye of its creator, in Man Ray's gaze, his pores, his hands, within his body: his camera is his brain. It is therefore obvious that he can often do without this mechanism, that at times he has had enough of it even to the point of despising it, and that he never cared much for the sophisticated perfectionism of electronic technology, preferring to use anonymous old cameras. His disdainful answer to students who submitted their proofs to him in America was, "You didn't make these, Mr. Kodak did." Man Ray was always above any camera.

Painting

We have examined two fundamental aspects of the *object* in relation to Man Ray: we defined the first as the *non-natural object,* the second the *photograph* as *object.* There is a third, vital aspect of his art: his *painting.* It is also first and foremost an object, as much from the point of view of technique as content. In the area of technique, Man Ray was always looking for a method which would be not only a perfect replacement for the paintbrush, but would go beyond it even if subsequently he was bound to continue making the best use of this ancient and very noble instrument.

15

Airbrushing was one of his most typical creations, and around 1917 he introduced it into his painting. Airbrushing gave him the intoxicating feeling of painting with his mind. Later, a great number of painters were to use this very fast process, but, at the time when Man Ray introduced this innovation—between 1917 and 1919—it still had all its revolutionary power. The airbrush is a psychological machine which only half belongs to painting. The other half falls within the province of science, and thus was one of the universal instruments for which Man Ray had a predilection.

The *object-painting* is fairly quickly enriched by another technical invention which was based on an original use of scraps of paper. The ten pictures—there could be, and indeed there are, more than a hundred—entitled, *Revolving Doors,* are exquisite, very technically refined creations which cut though painting like a ship's bow through a stormy sea. The first ones were collages achieved by superimposing transparent pieces of paper in order to obtain chromatic pictorial medleys. They are not hung on the wall, but arranged in pairs, back to back in the air so that they turn like a mobile. Doors continually open and continually closed in relation to space as a window on the unknown. Later, Man Ray made lithographs of them either because they should be multiplied like any other object, or because their chromatic form and composition resemble photographs. They are the photograms of painting.

In the later periods, he ingeniously produced the pictures, entitled *Equations Shakespeariennes,* another direct link with the machine. In fact they were originally a series of photographs of mathematical objects which represented algebraic equations kept for decades at the Poincaré Institut in Paris. Subsequently, they were stylized and became the *object-paintings,* the *Equations Shakespeariennes,* and one of the greatest most fascinating points in his creative life. They are too well known for us to need to discuss them here. But there are also the *natural paintings,* created by pressing two paint-covered surfaces together then separating them quickly, so that the resulting paintings were due partly to chance and partly determined by an initial outline.

When the enduring paintbrush reappeared, Man Ray also obtained astounding results, half way between the human and the mechanical. The great lips of the famous *A l'heure de l'observatoire, les amoureux* are an enormous machine floating in space, a spaceship from the farthest reaches of the galaxy. *Le Beau Temps* (1939), another masterpiece of all time, which—if we wish to analyze it, describes

a series of dreams—is primarily a complexity of machines: the picture is also a *marvellous object.*

Man Ray's pictural works are, in general, much more austere than his photographs, yet even though they are softened by color, the compositions seem to have been penetrated by an alien presence which torments them. A flower leans forward menacingly; mannequins seem to come from other dimensions; pawns seem to move of their own accord on the chess board; a shadow pursues a fleeing man; stones become portraits which seem to leap out from the camera. A whole series of ambiguous, contradictory presences—as much the result of the technique adopted by Man Ray as of the meaning which he consistently injects into his works—the appeal of his pictures is among the subtlest of our time. It is not only because they are always a little on the outside of painting no matter what the technique is, not only because of their unusual and abstruse beauty, but also because they have a dual nature: part painting, part science (the physical object); they are sustained by their creator's versatility and by the immense talent that allowed him tremendous virtuosity. The basis of his incandescent art lies in this great truth: Man Ray could also paint.

The machine becomes the painting, but painting devours everything.

PAINTINGS
OBJECTS
PHOTOGRAPHS

ART CENTER COLLEGE OF DESIGN LIBRARY

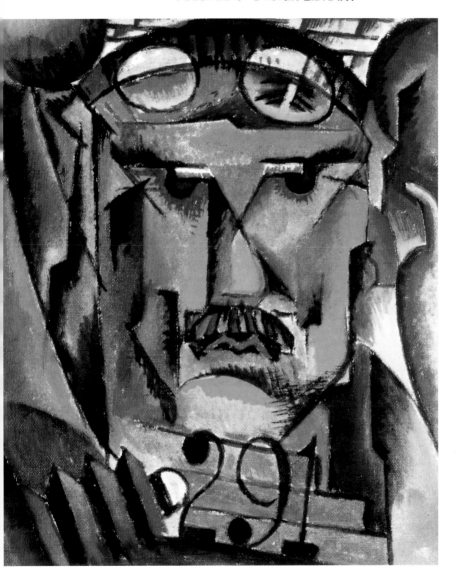

1 Portrait of Alfred Stieglitz 1913
Oil on canvas, 26.7 x 21.6 cm; Yale University Art Gallery, New Haven

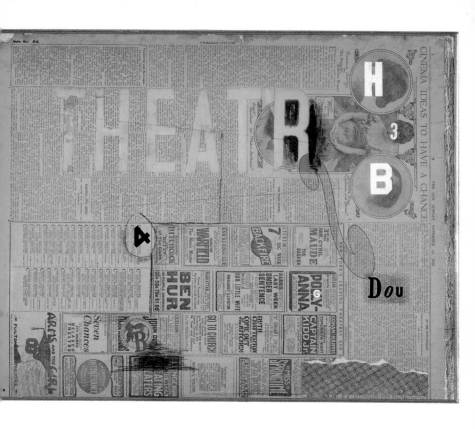

2 Theatre 1916
Paper collage, 45.8 x 61 cm; Moderna Museet, Stockholm

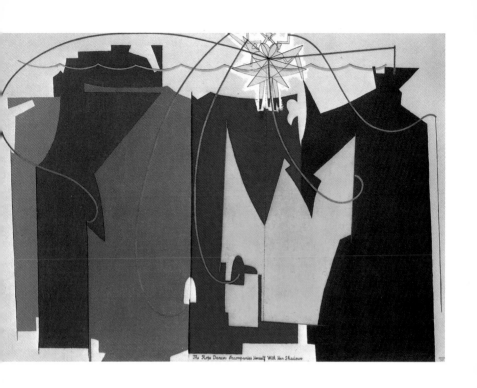

The Rope Dancer Accompanies Herself With Her Shadows

3 The Rope Dancer Accompanies Herself with Her Shadows 1916
Oil of canvas, 132.1 x 186.4 cm; The Museum of Modern Art, New York

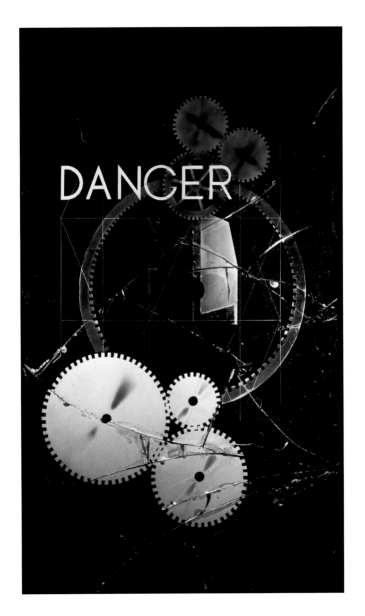

4 Dancer (Danger) 1920
Engraving on glass, 17.3 x 11.3 cm; Galleria Schwarz, Milan

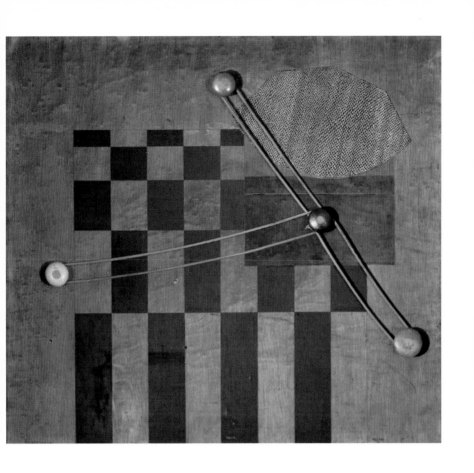

5 Boardwalk 1917/1973
Collage, 67 x 73 cm; Staatsgalerie, Stuttgart

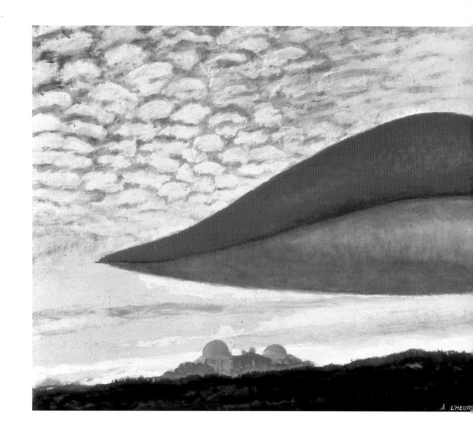

À L'HEUR

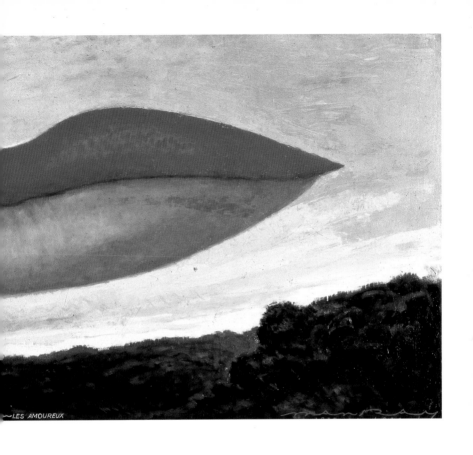

6 A l'heure de l'observatoire – Les amoureux 1934
Oil of canvas, 100 x 250 cm; Stavros Niarchos Collection

ART CENTER COLLEGE OF DESIGN LIBRARY

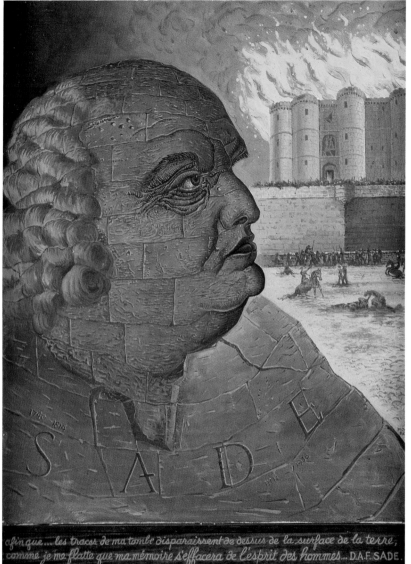

7 Imaginary Portrait of D.A.F. de Sade 1938
Oil on canvas and wood, 54.9 x 45.1 cm; The Menil Collection, Houston

8 Les vingt jours et nuits de Juliette / The Twenty Days and Nights of Juliet 1952
Oil on five-part screen, each part 255 x 60 cm; J.M.R. collection

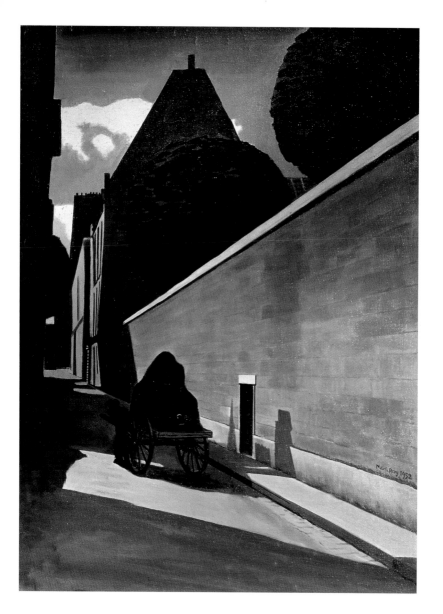

9 La Rue Férou 1952
Oil of canvas, 77.5 x 59.7 cm; Collection of Samuel Siegler, New Jersey

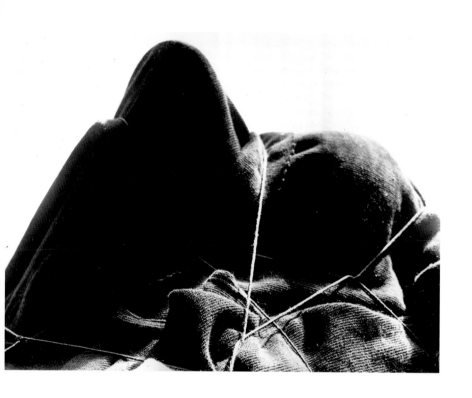

10 L'énigme d'Isidore Ducasse/The Enigma of Isidore Ducasse 1920
Sewing machine, blanket, cord, 74 x 22 x 30 cm;
photo: Man Ray; private collection, Paris

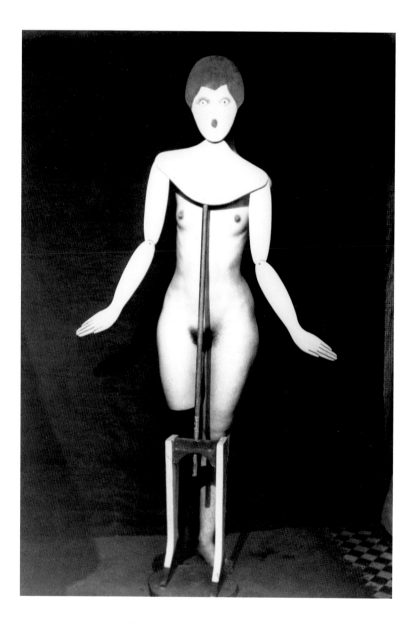

11 Portemanteau/Coatstand 1920/1972
Coat stand, nude; photo: Man Ray; Galleria Schwarz, Milan

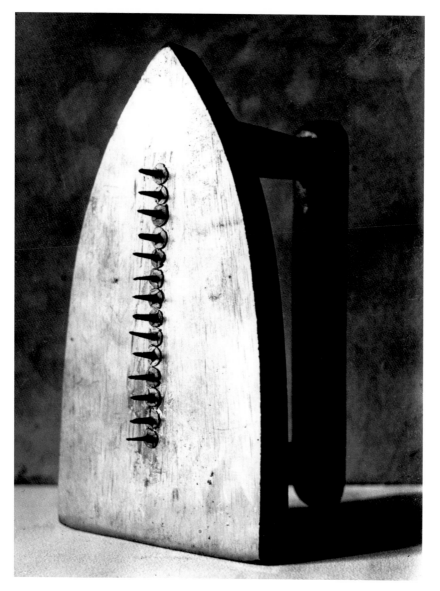

12 Cadeau 1921/1963
Present
Flat-iron with nails; photo: Man Ray; Galleria Il Fauno, Turin

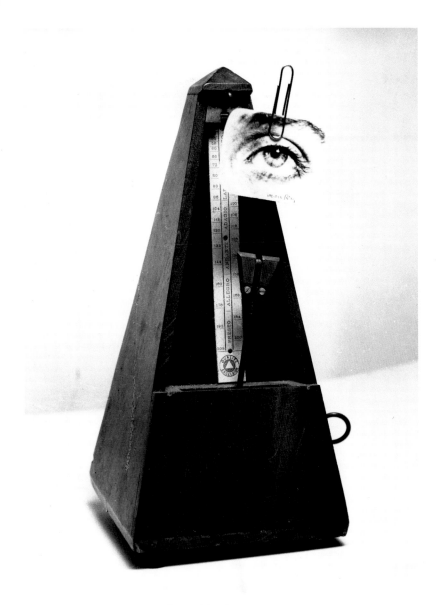

13 Indestructible Object 1923/1963
Metronome and photograph, height 23.5 cm; photo: Man Ray;
Collection of Vera and Arturo Schwarz, Milan

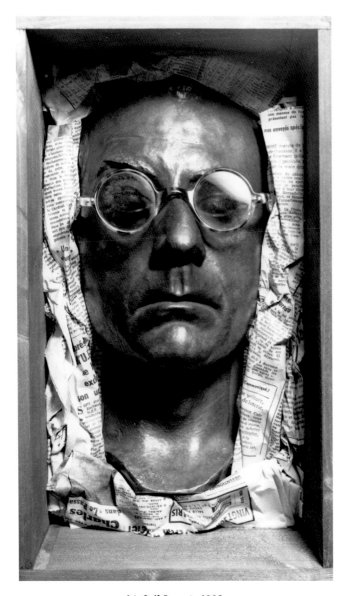

14 Self-Portrait 1932
Bronze, spectacles, wood, newspaper; photo: Attilio Bacci;
Collection of Vera and Arturo Schwarz, Milan

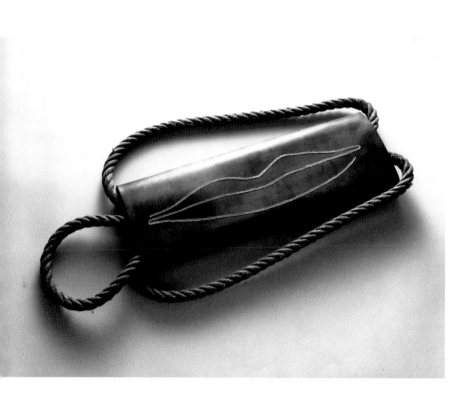

15 My Dream (The lovers) 1933/1972
Engraved lead with cord; Collection of L. Treillard, Paris

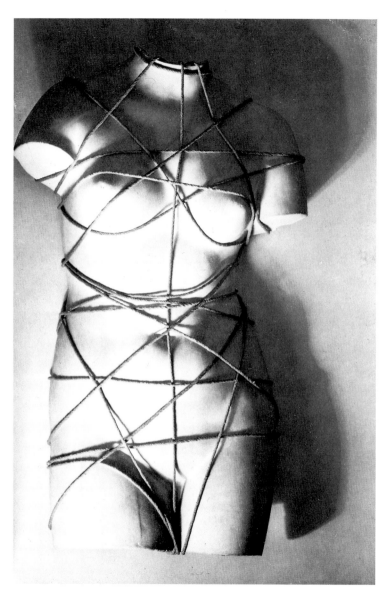

16 Vénus restaurée 1936
Venus Restored
Plaster model and rope, height 71 cm; photo: Man Ray

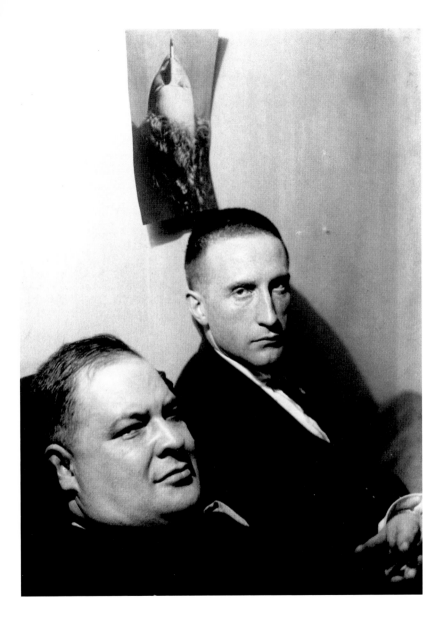

17 Joseph Stella and Marcel Duchamp 1920
Photograph

ART CENTER COLLEGE OF DESIGN LIBRARY

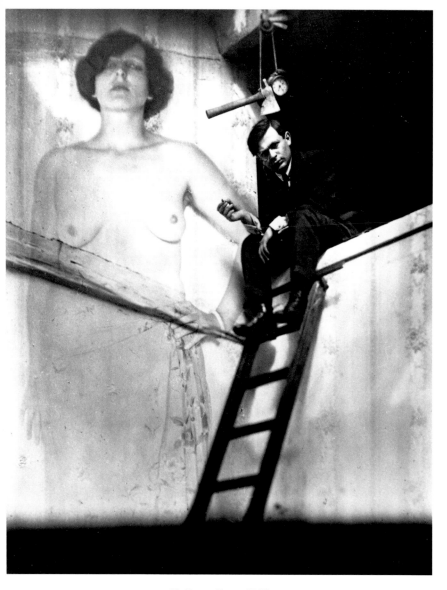

18 Tristan Tzara 1921
Photograph
Collection of Vera and Arturo Schwarz, Milan

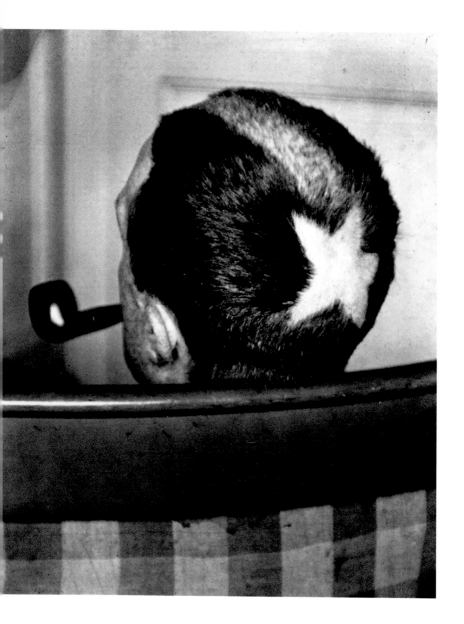

19 Tonsure (Marcel Duchamp) 1921
Photograph

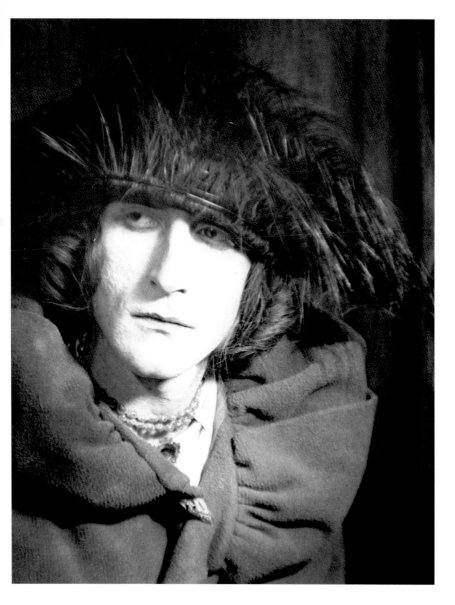

20 Marcel Duchamp, dressed up as his Dada alter-ego Rrose Sélavy 1921
Photograph

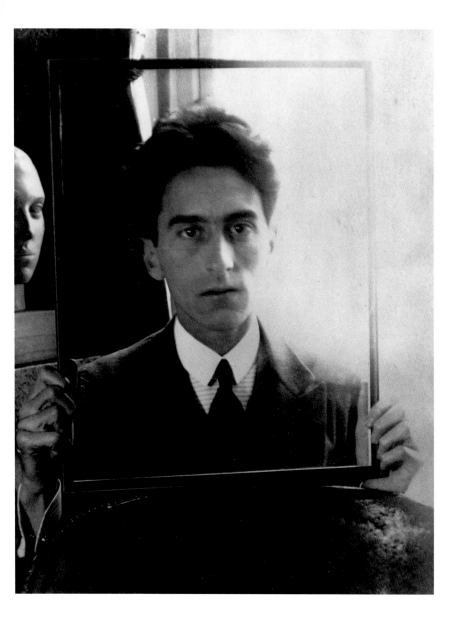

21 Jean Cocteau 1922
Photograph

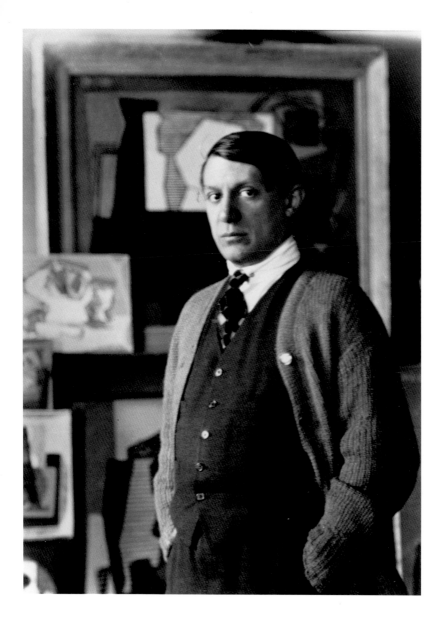

22 Picasso ca. 1922
Photograph

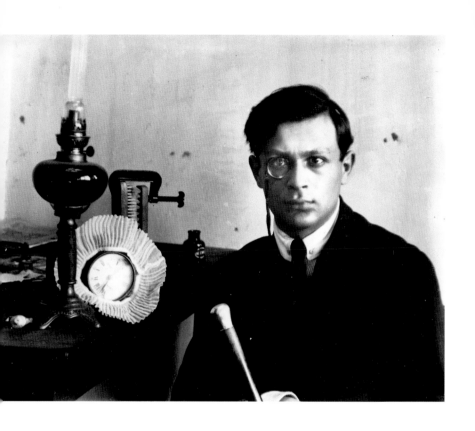

23 Tristan Tzara 1922
Photograph

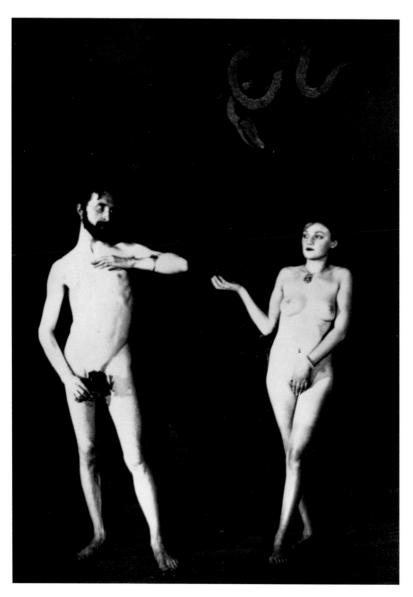

24 Ciné-sketch: Adam and Eve 1924
(Marcel Duchamp and Bronia Perlmutter)
Photograph

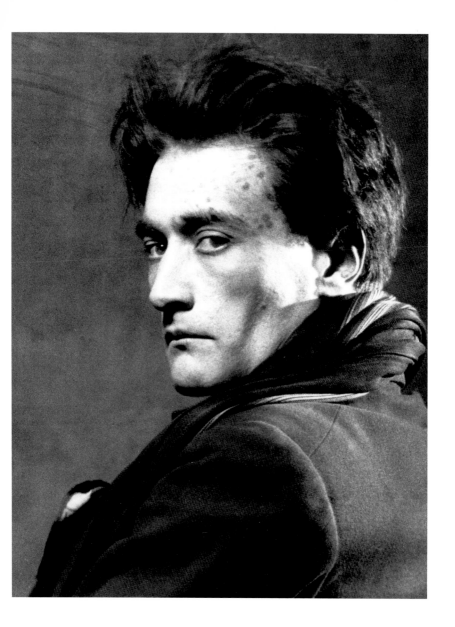

25 Antonin Artaud 1926
Photograph

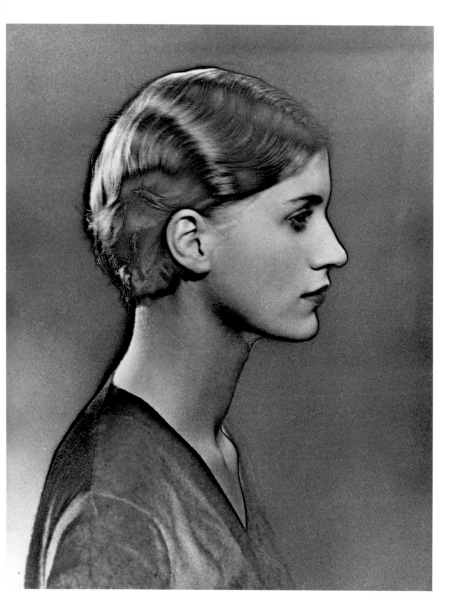

26 Portrait of Lee Miller 1930
Solarized silver print

ART CENTER COLLEGE OF DESIGN LIBRARY

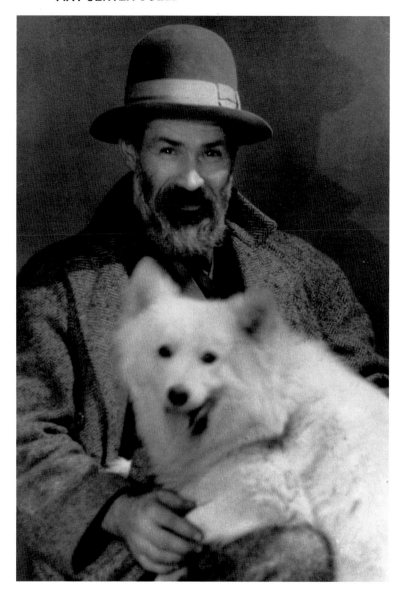

27 Constantin Brancusi 1930
Photograph

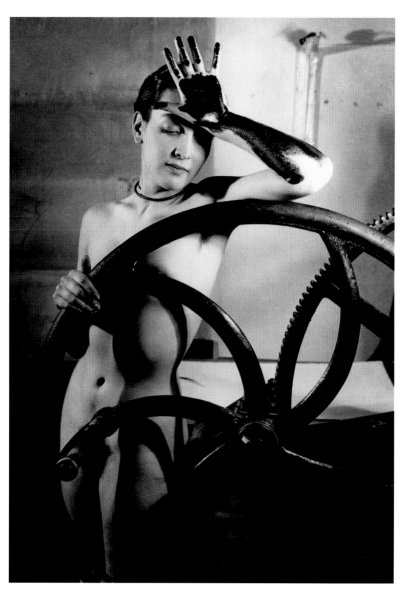

28 Erotique voilée 1933
Veiled erotic
Photograph (Meret Oppenheim in Marcoussis' studio)

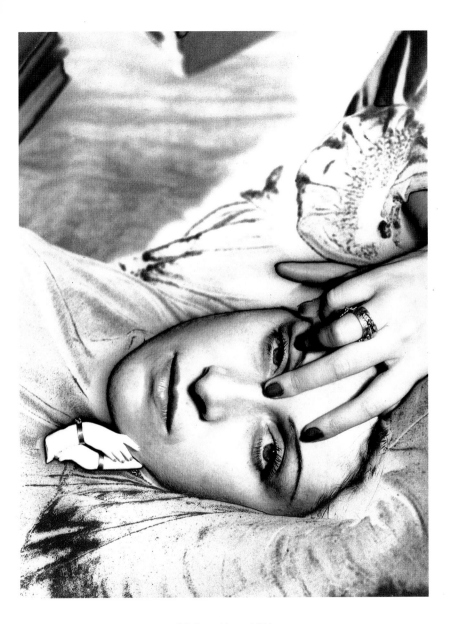

29 Dora Maar 1936
Solarized silver print

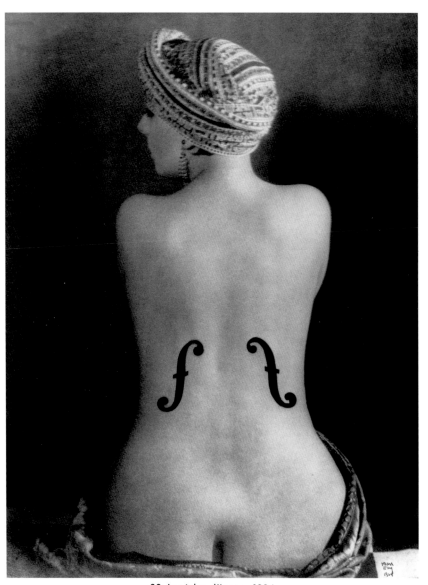

30 Le violon d'Ingres 1924
The Violin of Ingres
Retouched original photograph, 48.3 x 37.6 cm;
Collection of Mr. and Mrs. Melvin Jacobs, New York

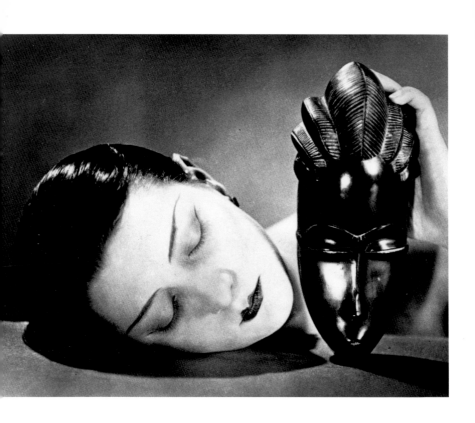

31 Noire et blanche 1926
Black and white
Photograph

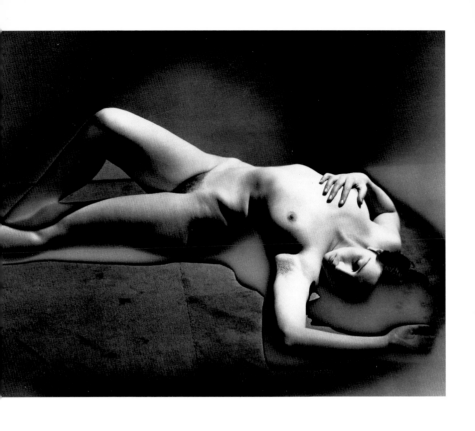

32 Primat de la Matière sur la Pensée/The Primacy of Matter over Thought 1931
Solarized silver print

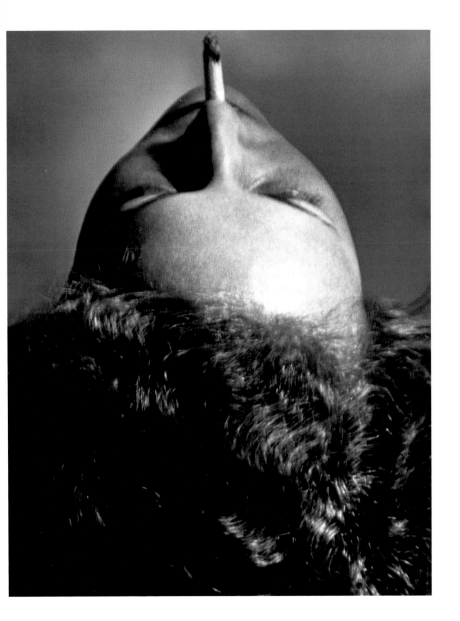

33 Untitled 1920
Photograph

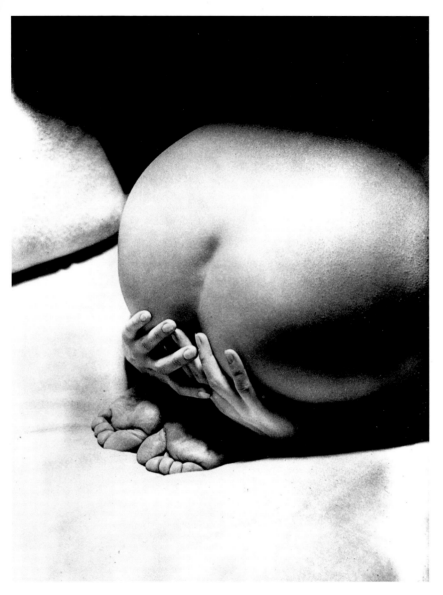

34 La Prière 1930
The Prayer
Photograph

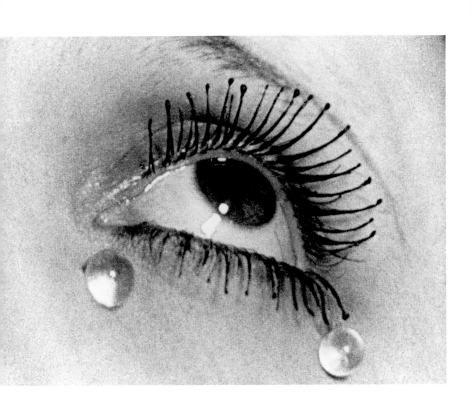

35 Larmes/Glass Tears 1933
Photograph

ART CENTER COLLEGE OF DESIGN LIBRARY

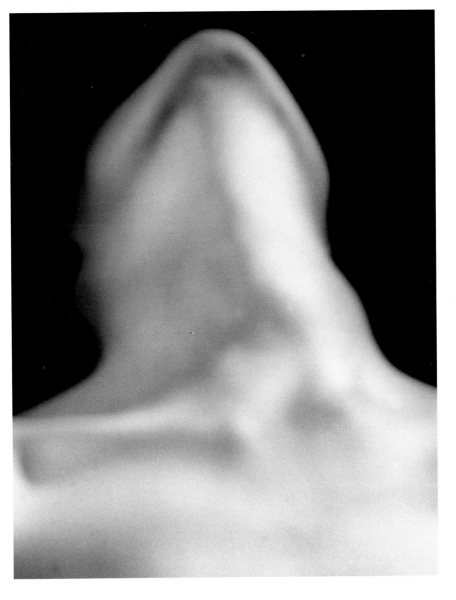

36 Anatomies ca. 1930
Photograph

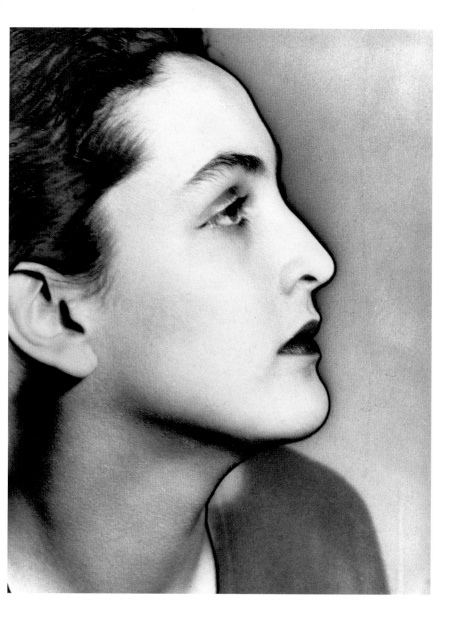

37 Untitled 1934
Solarized silver print

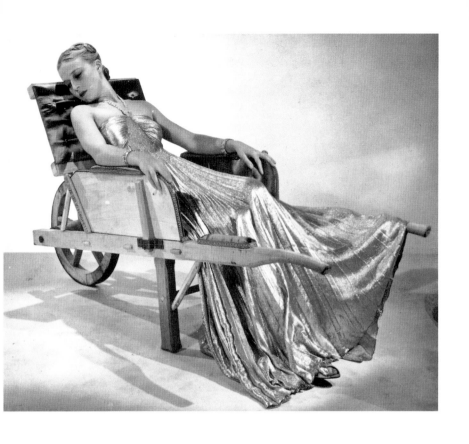

38 Robe de Lucien Lelong 1937
Lucien Lelong evening dress
Photograph; Collection of J.M.R.

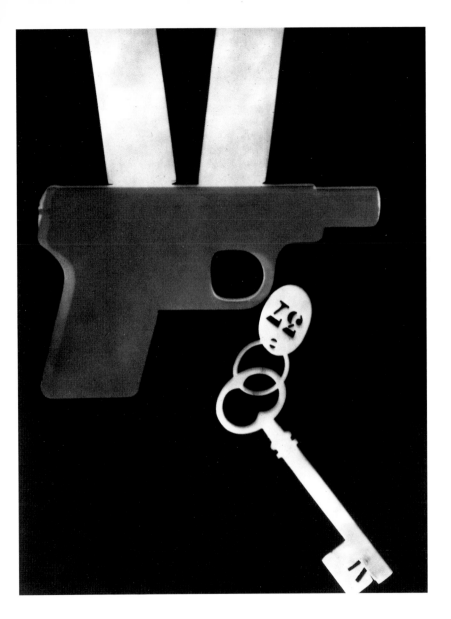

39 Untitled 1922
Rayograph

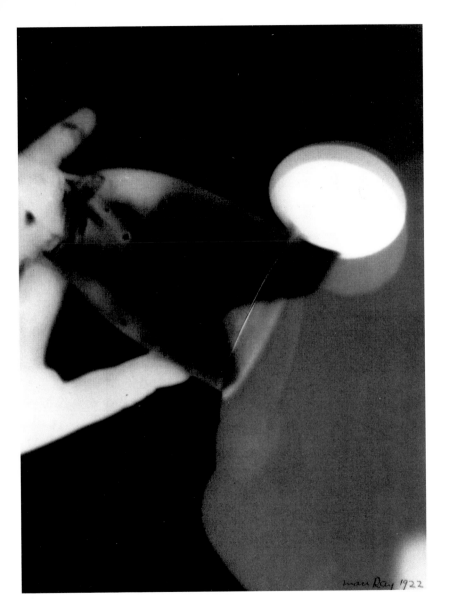

40 Kiki Drinking 1922
Rayograph

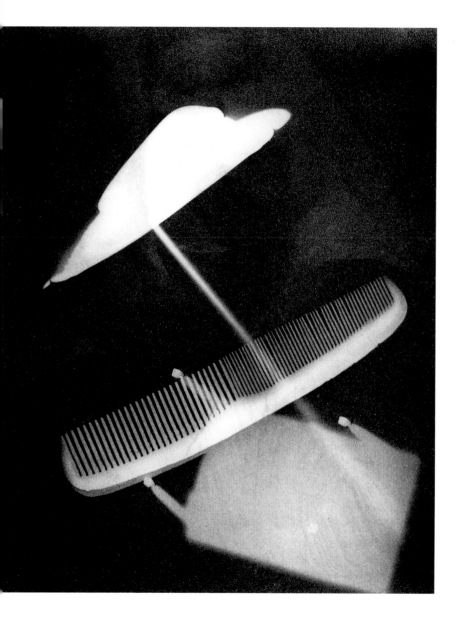

41 Untitled 1923
Rayograph

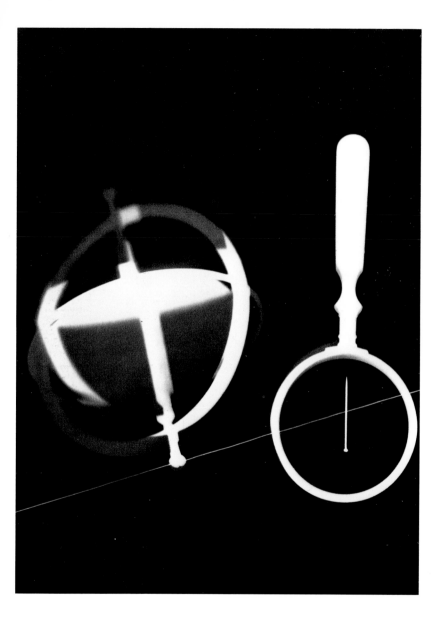

42 Untitled 1922
Rayographie (from the portfolio *Les Champs délicieux/The Fields of Delight*)

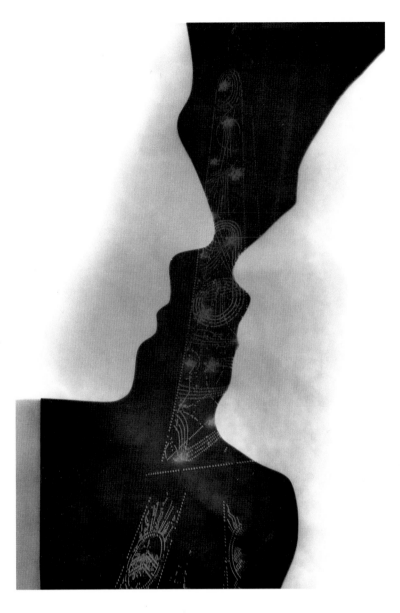

43 Untitled ca. 1922
Rayograph (illuminated Eifel Tower in the background)

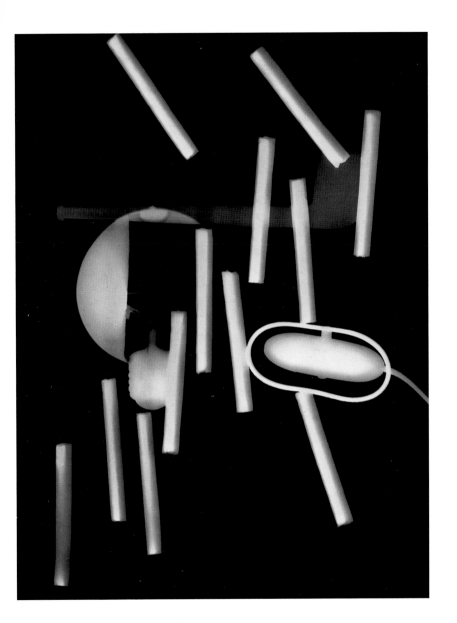

44 Untitled ca. 1922
Rayograph

ART CENTER COLLEGE OF DESIGN LIBRARY

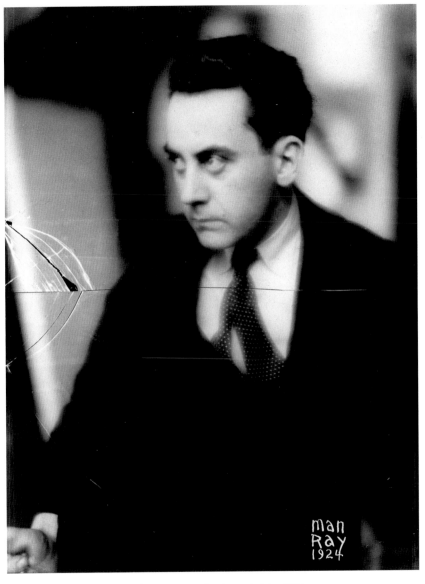

45 Autoportrait à la plaque brisée 1924
Self-Portrait with Broken Glass
Photograph; Collection of Hans Bollinger, Zurich

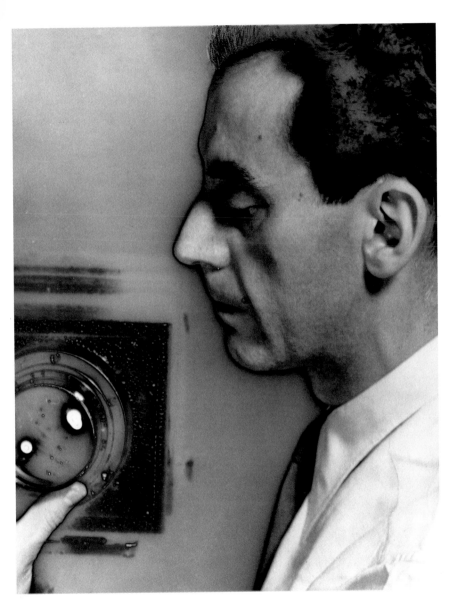

46 Self-Portrait with camera 1930
Solarized silver print; Bibliothèque Nationale, Paris

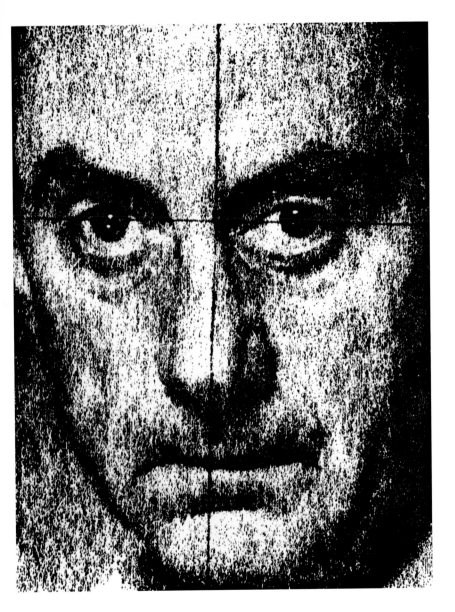

BIOGRAPHICAL NOTES

1890 Man Ray—there are various versions of what his real name was, including Emanuel Rud-
 nitzsky, Emanuel Radensky, Emanuel Rabinowitz, Raymond Mandelbaum, Michael Radnit-
 zky—was probably born on August 27, in Philadelphia, Pennsylvania, to Russian-Jewish
 parents.

1904 Attends high school in Brooklyn, New York.

1906 Begins to study architecture, but soon drops out of it.

1910 Takes courses in drawing and watercolor at the Ferrer Center, New York. Makes contact there
 with artists who frequent anarchist circles.

1911 First abstract work, *Tapestry,* produced by sewing together pieces of a material sample
 catalogue.

1913 First Cubist picture *Portrait of Alfred Stieglitz.* In May, marries Adon Lacroix (Donna
 Lecœur). Moves to Ridgefield, New Jersey. Visits the "Amory Show" in New York, where he
 is powerfully impressed by European avant-garde painters.

1914 First uses the signature "Man Ray."

1915 Publishes of *A Book of Diverse Writings,* with words by Donna and illustrations by Man Ray.
 In September or October, his first meeting with Marcel Duchamp, begins a lifelong friendship.
 In October and November has his first one-man exhibition in the Daniel Gallery, New York.

1917 *Suicide,* one of the first aerographs. First glass plate.

1919 Separates from Adon Lacroix.

1920 Establishes correspondence with Tristan Tzara. Sketch for the first chess game. Experiments
 in photography and film with Duchamp. Together with Duchamp and Katherine Dreier, Man
 Ray founds the "Société Anonyme Inc." on April 29,—the first association in the United
 States devoted to encouraging the exhibition and collection of modern works of art.

1921 July 14: Arrives in Le Havre on the French national holiday. Man Ray settles in Paris, and
 Duchamp introduces him to the leading Dadaist. In October he meets Jean Cocteau, who in
 turn introduces him to further circles of friends. In November, his first rayograph. In
 December, he meets the model Kiki (Alice Prin). For the following six years they are to live
 and work together.

1922 Professionally concerned with photography. Numerous portrait photos. Title photos for
 Mecano, The Little Review, Ma, Lex Feuilles Libres, Aventura.

1923 Man Ray makes his first film, *Le retour à la raison.*

1924 First monograph on Man Ray, by Georges Ribemont-Dessaignes.

1925 Takes part in the first Surrealist exhibition with Hans Arp, Giorgio de Chirico, Max Ernst, André Masson, Joan Miró, Pablo Picasso at the Galerie Pierre, Paris.

1926 June 23: opening of the *Surréaliste* gallery, showing *Tableaux de Man Ray et objets des îles.*

1928 May 13: première of the film *L'Etoile de mer* in Paris.

1929 In October, the première of the film *Mystères du Château de Dés* in Paris.

1930 First solarized silver prints.

1936 Takes part in the "International Surrealist Exhibition" at the New Burlington Gallery in London. Visits New York. Participates in the exhibition "Fantastic Art, Dada, Surrealism" at the Museum of Modern Art, New York.

1937 Publication of the essay "La Photographie n'est pas de l'art."

1940 Shortly before the occupation of Paris by German troops, Man Ray flees to America via Lisbon on June 14. Settles in Hollywood.

1941 He makes contact with Walter Arensberg and Hollywood's artistic circles.

1946 Double wedding in Beverly Hills: Man Ray marries Juliet Browner, whom he met in Hollywood in 1940, and Max Ernst marries the painter Dorothea Tanning.

1951 Returns to Paris.

1956 Exhibition, "Man Ray, Max Ernst, Dorothea Tanning" at the Musée des Beaux-Arts, Tours.

1958 Takes part in the exhibition "Dada, Dokumente einer Bewegung" at the Kunstverein Düsseldorf, and a Dada exhibition at the Stedelijk Museum in Amsterdam.

1961 Receives the Gold Medal for photography at the Venice Biennale.

1963 His autobiography, *Self Portrait,* is published in London.

1966 Takes part in the Dada retrospective shown at the Musée National d'Art Moderne in Paris, at the Kunsthaus in Zurich, and at the Civico Padoglio d'Arte Contemporanea in Milan. First major retrospective at the Los Angeles County Museum of Art.

1967 Exhibition "Salute to Man Ray" at the American Center, Paris.

1971 Retrospective at the Museum Boymans van Beuningen in Rotterdam and at the Galleria Schwarz in Milan.

1972 Retrospective at the Philadelphia Museum of Art. The Rotterdam retrospective travels to the Musée National d'Art Moderne in Paris and the Louisiana Museum in Humlebæk (Denmark).

1974 Takes part in the exhibition "New York Dada" (Städtische Galerie, Munich and Kunsthalle, Tübingen). One-man exhibition, "Man Ray: Inventor—Painter—Poet" at the New York Cultural Center, on the occasion of his 85th birthday.

1975 Major one-man exhibitions in London (Mayor Gallery), Milan (Studio Marconi), and Athens (Iolas Gallery).

1976 Man Ray dies in Paris on November 18.

BIBLIOGRAPHY

Cocteau, Jean, Francis Steegmuller, Man Ray. *Le numéro Barbette.* [N.p.]: Damase, 1980. [In English, French, and German.]

Man Ray. *Photographs by Man Ray: 105 Works, 1920-1934.* With texts by P. Eluard, A. Breton, R. Sélavy [i.e. M. Duchamp], T. Tzara. New York: Dover, 1979. [Reprint of first edn., 1934.]

Man Ray. *Man Ray: Bazaar Years,* ed. John Esten, intr. Willis Hartshorn. New York: Rizzoli, 1988.

Man Ray. *Self Portrait,* with afterword by Juliet Man Ray and foreword by Merry A. Foresta. Boston: Little, Brown, 1988.

Martin, Jean-Hubert. *Man Ray Photographs.* London: Thames and Hudson, 1991.

Penrose, Sir Roland. *Man Ray.* Boston: New York Graphic Society, 1975.

Schwarz, Arturo. *Man Ray: the Rigour of Imagination.* New York: Rizzoli, 1977.

PHOTO CREDITS

Courtesy of The Menil Collection, Houston, Texas: no. 7; Moderna Museet, Stockholm: no. 2; Arturo Schwarz, Milan: nos. 13, 14; Socitéte Civile Man Ray, Paris: nos. 1, 3, 4, 6, 8, 9, 10, 11, 12, 15, 16, 17, 18, 19, 20, 21, 22, 23, 24, 25, 26, 27, 28, 29, 30, 31, 32, 33, 34, 35, 36, 37, 38, 39, 40, 41, 42, 43, 44, 45, 46, 47; Staatsgalerie, Stuttgart: no. 5.

90 May '03 Daedalus 7.98 (1)-95 87892

96 206MI FM 8261
6/03 30025-146 NLB